From Wounded Knee to the Edmund Pettus Bridge, and from the Upper Big Branch mine disaster to the Trail of Tears, *Marked, Unmarked, Remembered* presents photographs of significant sites from U.S. history, posing unsettling questions about the contested memory of traumatic episodes from the nation's past. Focusing especially on landscapes related to African American, Native American, and labor history, *Marked, Unmarked, Remembered* reveals new vistas of officially commemorated sites, sites that are neglected or obscured, and sites that serve as a gathering place for active rituals of organized memory.

These powerful photographs by award-winning photojournalist Andrew Lichtenstein are interspersed with short essays by some of the leading historians of the United States. The book is introduced with substantive meditations on meaning and landscape by Alex Lichtenstein, editor of the *American Historical Review*, and Edward T. Linenthal, former editor of the *Journal of American History*. Individually, these images convey American history in new and sometimes startling ways. Taken as a whole, the volume amounts to a starkly visual reckoning with the challenges of commemorating a violent and conflictual history of subjugation and resistance that we forget at our peril.

Alex Lichtenstein, current editor of the *American Historical Review*, is a professor of history at Indiana University. The author of many articles on labor, prison, and civil rights history, his previous work on photography is *Margaret Bourke-White and the Dawn of Apartheid*.

Andrew Lichtenstein is a photographer, journalist, and educator from Brooklyn, New York. His first book *Never Coming Home* was published in 2007.

UN

REME

WEST VIRGINIA UNIVERSITY PRESS
MORGANTOWN • 2017

MARKED

ANDREW LICHTENSTEIN and ALEX LICHTENSTEIN with a foreword by Edward T. Linenthal

MARKED

with essays by KEVIN BOYLE, DOUGLAS EGERTON, SCOT FRENCH, MICHAEL K. HONEY, STEPHEN KANTROWITZ, ARI KELMAN, GARY Y. OKIHIRO, JULIE REED, CHRISTINA SNYDER, AND CLARENCE TAYLOR

MBERED

Copyright 2017 by West Virginia University Press

All rights reserved

Printed in the United States of America

ISBN: PB 978-1-943665-89-1

Library of Congress Cataloging-in-Publication Data is available from the Library of Congress.

Book and cover design by Than Saffel / WVU Press.

CONTENTS

FOREWORD

Sitting with this provocative archive of photographs reminded me of the work of two of my favorite historians, Robert Orsi and Patricia Limerick. Orsi's book *History and Presence* asks readers to take seriously that for most of human history, the presence of the gods was, well, taken seriously. "To be in relationship with special beings really present is as old as the species," he writes, "and as new as every human's infancy." Substituting "places" for "beings" does not, I think, weaken the declaration. Patricia Limerick points to certain kinds of beings and places in a book chapter, "Haunted America": "These haunted locations are not distant exotic sites set apart from the turf of our normal lives. Neither time nor space, it would seem, can insulate us from these disturbing histories. . . . We live on haunted land, on land that is layers deep in human passion and memory. . . . Here, land is to be reoccupied, revisioned by memory, by story, by reanimating the land with indigestible stories." I can imagine Orsi replying to Limerick with another evocative statement in *History and Presence*, "Presence is a fearsome thing. . . . Presence forever exceeds the bounds set for it."[1]

It is not unusual to think of sites as transformed forever by violence. I recall a high school trip to Gettysburg when the words of a longtime Gettysburg guide—that there was a "brooding omnipresence" to the place—felt so true. I think of words that have bounced around my mind for many years, from a time when I was writing about the transformation of the Little Bighorn battlefield from a shrine to George Armstrong Custer to a historic site for all Americans. I was speaking with a National Park Service historian, a member of the Crow tribe, and I told her of

the overwhelming sense of presence I felt every time I visited. She said very matter-of-factly, "I have seen the riders on the field." Presence indeed.

What does it mean to call a place "haunted"? There can, of course, be a playful commercialism to ghost tours at historic sites, but Limerick and others mean something quite different. These places are haunted, in part, because the stories rest uneasily with us. In *Possessions: The History and Uses of Haunting in the Hudson Valley,* Judith Richardson observes, "Ghosts operate as a particular, and peculiar kind of social memory, an alternate form of history-making in which things usually forgotten, discarded, or repressed become foregrounded, whether as items of fear, regret, explanation, or desire."[2]

Presence, absence, brooding omnipresence, haunted landscapes populated by restless stories: all are present in Andrew Lichtenstein's compelling work. He asks us to look at some places directly, but not always. Sometimes he asks us only to look, as we learn in the introduction, at the margins, his eye only lets us approach a place. Sometimes we are at the center, but still not exactly. We don't see a tree from which Jesse Washington was lynched, we see his descendants and wonder about the enduring impact of such events. Being allowed to share this intimate moment with them through Lichtenstein's photograph demands that we pay our respects, that we become custodians of difficult history through remembrance of these most indigestible of our stories.

His eye captures absence as well as presence, or perhaps better, absence that is as revelatory of memorial processes as acts of remembrance. Think of the empty space where once stood John Mason's monument in Mystic, Connecticut, remembering his leadership in the massacre of Pequot Native Americans in 1637. We see the empty site, filled now not with a monument, but with questions: What communities asked for the monument to be removed? Who

(if anyone) argued for its continued presence? How volatile were the discussions? What were the reasons offered for removal? Is this a site of significant absence, or now a site consigned to oblivion because of the loss of any physical marker?

Lichtenstein takes us to the cotton fields of Money, Mississippi, to engage the horrific story of the murder of Emmett Till. True, there is not much left in Money to allow visitors to feel the physical reality of the event, but there is still the evocative ruins of the Bryant drugstore. These ruins have become remembered even more intensely with the recent wave of scholarship on the Till murder, and the fact that the store is in ruins reminds us that there is a life cycle to such places. And for many, the ruins are graphic evidence of the urge to let indigestible stories and sites quietly disappear. The ruins have become their own unique site of remembrance.[3]

There is emptiness and desolation in this collection. And there are intense faces of people struggling with the presence of the past. Lichtenstein's photographs and the accompanying essays fill the emptiness and populate the desolation with stories that bring these sites alive, "reanimating the land," as Limerick noted, "with indigestible stories." Perhaps we have no good language for enduring affliction, the scars of memory, but Lichtenstein's archive asks us to pay attention to these scars, to insist on the integrity of memory and the fullness of history.

—Edward T. Linenthal
September 11, 2016

INTRODUCTION

MARKED, UNMARKED, REMEMBERED

Alex Lichtenstein

People do not remember in isolation, but only with help from the memories of others: they take narratives heard from others for their own memories, and they preserve their own memories with help from the commemorations and other public celebration of striking events in the history of their group.

—Paul Ricocur, *Memory, History, Forgetting*

So far as an unofficial knowledge and popular memory are concerned, the peculiarities of the landscape might be a better place to begin.

—Raphael Samuel, *Theatres of Memory*

Oh, how those of us fascinated by the past wish we could time-travel! As many people have proclaimed, "the past is a foreign country," but, alas, it is not a destination we can visit as tourists. Or not exactly. For, while we cannot transport ourselves physically to a different moment in time, we still can travel to and see, and smell, and touch, and walk, and inhabit the *places* where the past, distant or near, has unfolded.

This desire for physical proximity to the geography of the past—and the claim to authenticity embodied in those physical spaces—is, one suspects, what underlies the mania for "heritage," preservation, memorialization, and reenactment that constitutes much contemporary public engagement with history.[1] Certainly preserved objects that carry with them the "aura" of the past continue to bear weight: witness the excitement of discovering Nat Turner's bible kept as a family heirloom over generations, and its subsequent display and sacralization in the National Museum of African American History and Culture, inaugurated on the mall in Washington, D.C., in September 2016.[2] Objects, however, get destroyed, damaged, lost, found, restored, moved, and placed in a museum as venerated icons; as public historian David Glassberg has observed, our "sense of history" often instead remains rooted in physical geography.[3] Still, as Andrew Lichtenstein's photographs in this volume suggest, the confluence of landscape, event, and memory is no simple doorway into an unmediated past. Andrew's effort to document "sites of memory," as French historian Pierre Nora famously called them, explores the interstices between public remembering and public forgetting at locations of violent trauma in American history. Since this history—like that of nearly all other nations and regions—is one surely soaked in blood, these sites should not, in principle, be hard to find. Some indeed are boldly marked, given an imprimatur as part of our indelible "national heritage" by federal, state, and local authorities. Others remain largely forgotten—or at least unmarked, and thus not immediately visible to the casual observer or the traveler speeding by on the freeway. But invisibility does not erase the stain of what occurred there, for nothing can. In these instances, such events constitute, "a kind of phantom history, a story at once strangely present and absent . . . haunting places but never fully inhabiting them."[4] Finally, whether marked or unmarked, remembered or forgotten, some sites become the meeting point for active rituals of organized memory, attempts to refuse the national

bad habit of amnesia when it comes to some of the more unsavory aspects of the history of these United States.

To be sure, developments over the past two decades bode well for a more thorough reckoning with the traumatic episodes of the American past. The academic explosion of fields like African American, Native American, Japanese American, women's, and labor history has at last begun to make its indelible mark on our public history. The National Park Service maintains a National Historical Trail commemorating the injustices of Cherokee removal from the southeast. Curators at the Museum of African-American History and Culture have ensured that visitors cannot miss photographs of lynching or the murdered Emmett Till's casket. The Equal Justice Initiative, in Montgomery, Alabama, will soon open a museum that documents racial atrocities "from slavery to mass incarceration," not far from the moving memorial to slain civil rights activists erected by the Southern Poverty Law Center. Nevertheless, this is just a start. Many sites of lynching and racial pogroms, massacres and dispossession of Native peoples, and the violent suppression of workers' efforts to demand their rights, remain unmarked and unacknowledged, confined to the realms of rumor, local lore, or family memory.

This book marks a very particular kind of long-deferred fraternal collaboration and engagement with this question of how we use landscape and topography to rethink the past. For seven years, my brother Andrew has journeyed around the United States in an effort to document infamous historical sites. He initially envisioned a project entitled "Landscapes of American History," conducted under the auspices of the Facing Change collective's efforts to "document America," much the way Farm Security Administration (FSA) photographers did during the Great Depression of the 1930s. The project also garnered support from the Aftermath Project's determination to render visible the lingering effects of social trauma; Andrew's quest

subsequently developed a life of its own as he amassed a portfolio of these images from around the country.[5] As Andrew told the Aftermath Project in 2012, he "always believed that the first step towards healing a deep wound is acknowledgement," a notion quite consonant with that of historians and museum curators who seek to make memory central to their engagement in public history in places of violence as diverse as Berlin, Johannesburg, and Birmingham, Alabama. At the same time, Andrew's photographs approach historical monuments somewhat sideways. He begins with a historical event of potential interest, and then goes to look for a likely photographic opportunity, recording what he discovers while wandering around the established site of memory. Sometimes—often—there is nothing to see at first glance. "In almost every case what I find is not the picture I went down there to make," he points out in a 2013 interview about his work process. "What we choose to forget and ignore is often more interesting to me than what we've chosen to honor and celebrate."[6] For my part, while Andrew has traveled with his camera, I have spent my career in historical archives, exploring the nature of past struggles for racial justice in both the United States and South Africa. Yet I remain nagged by the sense that the academic accounts such research produces fall on deaf ears, and thus I have increasingly been drawn to visual modes of historical narrative. Andrew and I have long contemplated how we might bring our parallel historical investigations and sensibilities into dialogue, and a book of Andrew's photographs struck us as the best way to do so.

At first, we imagined that such a project should be organized around one of two axes. Since, broadly speaking, the photographs collected here speak to particular historical themes—drawn from Native American, African American, and labor history in particular—we considered grouping the photographs around these issues. But we quickly realized that this would merely replicate a too often balkanized historical narrative, one that tends to treat the traumatic

aspects of these supposedly "ethnic" pasts marked by struggle as separate from both the main exceptionalist narrative of the allegedly "innocent" American past, as well as from one another. Instead, we regard these pasts as constituent and interrelated parts of a rich and complex history marked by violent conquest, slavery, racism, and class conflict that together create a shared legacy and thus a shared responsibility. Another option, since the spectral past resides in many places and manifests itself in many forms, was to organize the material primarily by its visual qualities—portraits, landscapes, action, objects, buildings, interiors, and so forth. While having the advantage of letting Andrew's photographs speak for themselves as visual objects, this approach still would have obscured our main purpose: to draw on the visual power of Andrew's photographs to inquire how one might choose to remember aspects of the past many Americans would prefer to forget.

Hence, our title and the organizing principle of the book—foregrounding the active process of relying on competing forms of memorialization to imprint a collective understanding of the past on both the human and natural landscape: *marked, unmarked, remembered*. Although we came to this triptych independently, in some important ways it echoes the categories imposed on historical landscapes by geographer Kenneth Foote, in his book *Shadowed Ground* (1997). Foote divides American sites of "violence and tragedy" into four categories: sanctification, designation, rectification, and obliteration. As Foote reckons, while the process of memory-making entails "major modifications of the landscape," at the same time "the physical durability of landscape permits it to carry meaning into the future." To put it another way, whether commemoratively marked, left derelict, or restored as a site of active memorialization—the latter activity usually correlated with a significant moment in time, such as an anniversary—the physical site of historical trauma does not shift, even if it undergoes transformation or reinterpretation, both

natural and human-made. For Foote, this makes these sites of memory fixed points of analysis, allowing him to explore what he calls forms of "earth writing"—geo-graphy—in order to "explain how Americans have come to terms with violence and tragedy."[7]

Strikingly, some of the sites Foote analyzes were ones that Andrew unwittingly visited over a decade later—certainly a potent indicator of their continuing historical resonance. Yet, while ultimately raising many of the same questions about the intersections of landscape, memory, and trauma, Andrew's vision, I believe, remains quite distinct from Foote's. *Shadowed Ground* contains over 150 photographs of the sites Foote considers (most of them taken by the author himself). Yet these images, while not exactly incidental, function primarily as illustrations of the argument laid out in Foote's text. *Marked, Unmarked, Remembered*, by way of contrast, comes at the questions raised by landscape from the other direction: the key to unlocking the mysteries of the "shadowed ground" captured in Andrew's photographs can be found in the exposures themselves. The short explanatory captions we have written to accompany each photograph— as well as the reflections we have commissioned from prominent historians intimately familiar with some of these sites and knowledgeable about what transpired there— stand, in essence, as textual "illustrations" of the potential meaning residing in the images, not the other way around.

Foote's book explores the often conflictual process by which certain sites are imbued with cultural resonance and historical meaning, while others continue to remain unacknowledged. Andrew's photographs ask us to contemplate each site as it stands now (or when he took the photograph), and to use that image to meditate on the potential meanings of an unresolved past—a visual equivalent of Germany's *Stolperstein* (stumble-stones), marking the sidewalk in front of former residences of people rounded up and sent to their deaths by the Nazis. To put it most bluntly, what you hold in your hands is a photography book supplemented with text, not

a book of scholarship illustrated with photographs. We hope the photographs demand that you stop and *look* at something you may not have noticed before. While certainly worth placing on your bookshelf—or your coffee table—next to Foote's *Shadowed Ground,* in truth a more appropriate companion might be South African photographer Cedric Nunn's work, *Unsettled: The 100 Year War of Resistance by Xhosa Against Boer and British* (2015). Nunn's landscape photographs of the Eastern Cape, a region "drenched in blood" by the legacy of settler colonialism, rarely record officially "marked" memorial sites. Nevertheless, as novelist Zakes Mda observes in his introduction to the book, "landscapes are storage places of memory."[8] "Unsettled," of course, contains a double—indeed, a triple—meaning. Before the arrival of European intruders, the beautiful land In this corner of southern Africa remained "unsettled" in the sense that it was inhabited and used by the indigenous people who lived there, the Xhosa, prior to the depredations of settler colonialism. Xhosa memories, history, and culture still attach to the landscape, even when left invisible or deliberately obliterated, to use Foote's term. Yet over the centuries colonialism, war, and apartheid have laid their own claims to this land—thus leaving the contested legacy of the region "unsettled," in the sense that its current inhabitants and owners still have much to reckon with over a buried past. Finally, I assume, Nunn, like Andrew, intends that his photographs will have an "unsettling" effect on the viewer, reminding us that this beautiful landscape contains more than immediately meets the eye, both where the unsettled past is explicitly memorialized and, especially, where it is not. I think Andrew's work is designed to have much the same disquieting effect on the ways we contemplate the past of North America's own legacy of violent subjugation—by making it visible.

Rendering the absent visible by unsettling the viewer requires work and imagination. Whenever possible, historians try to visit the physical location of the events they are writing

about, no matter how distant in time. I certainly always counsel my graduate students to do so, and they invariably return with tales of how the past has taken up a new "presence" in their consciousness, which they often described in the language of phantoms, specters, ghosts. Unlike historians, who might confine themselves to the archives, photographers interested in recording the presence of the past have no choice but to tread on the ground inhabited by these phantoms. Even though the ghosts remain imperceptible to the camera's eye, such visits can yield some striking apparitions. As Andrew reminded me, when he visited the Jackson County Courthouse in Scottsboro, Alabama, he encountered a descendant of the doctor who initially examined the alleged rape victims, Ruby Bates and Victoria Price, thus helping to set in motion one of the most important legal struggles for racial justice in the pre–civil rights era. Or take Nat Turner's hideout at Cabin Pond, hidden deep in Virginia's Great Dismal Swamp. As Scot French suggests in his essay, the unmarked location may be "best viewed as a socially constructed space rather than a bounded geographic entity or point on a map." True—yet when Andrew visited the area in 2010, while he was tramping around the woods by the pond, the local sheriff pulled up, and asked him if he knew where he was. When Andrew replied that he did, the law officer easily recalled how as a boy he had shown the exact spot to William Styron, author of *The Confessions of Nat Turner*, the controversial novel about the slave rebel's life.

Such serendipitous encounters offer two important reminders. First, given the relatively foreshortened nature of the American past—at least in terms of the direct interactions of European settlers, indigenous peoples, and enslaved Africans—such sites retain their immediacy for many local residents, who attach their own memories to events and their reverberations that, after all, took place in their communities (if not in their own lifetimes) and often involved their ancestors. Julie Reed's essay on the Cherokee removals, written by a historian with a personal

stake in the story, provides a poignant example of this dynamic. Second, there is no avoiding the fact that the categories of memorialization we rely on to arrange the photographs in the pages that follow—marked, unmarked, remembered—are always fluid and contested, as is historical memory itself. Groups of interested citizens demand that sites unacknowledged, whether through benign neglect or deliberate efforts at forgetting (or keeping secret), become officially marked. Official recognition, usually by the state, however, can fix one meaning to a site, while obscuring others or directing attention away from alternative, potentially powerful mnemonic aspects of a landscape. The AME Emanuel Church in Charleston, South Carolina, a potent reminder of the history of African American self assertion, sits after all on Calhoun Street, named after the nation's most ardent defender of slavery, and its memorial meaning has necessarily shifted because of the recent tragic events that took place there; Henry Ford's statue at the River Rouge calls attention away from the memories cherished by the United Automobile Workers' union at that spot. Groups and individuals engaged in memory-work may reappropriate marked sites for their own commemorative purposes, acts, or rituals; sometimes, even, marked sites are erased, hidden, moved, or reinterpreted by forces hostile or friendly to a particular set of memories. As I write this, for example, I read that vandals in Mississippi recently riddled a sign commemorating the murder of Emmett Till with buckshot. Other sites, such as the infamous "Grassy Knoll" above Dealey Plaza, come to symbolize far more than the sudden, cataclysmic event that transpired at the spot they mark. Thus, while our tripartite "categorization" of Andrew's photographs follows logically from what caught his attention when he visited these sites, these designations are by no means definitive or uncontested. That is part of the point of his using the camera's eye to capture and freeze these landscapes—even if only fleetingly—to pin down an otherwise protean sense of historical meaning, as if jotting out a rapidly fading dream upon awakening, lest one forget its potential significance.

Unlike dreams, which follow their own narrative logic, history, we are so often told, is about narrating "change over time." As Kate Brown, a self-described historian "of places not yet forgotten," contends, "often places ostensibly rich with meaning have, at first glance, little power to narrate history and its significance." Brown explicitly compares the carefully curated space in which most historians, including me, conduct their investigation of the past—the archives— to the "places" where she often travels as an historical explorer, noting that in the latter case "when a researcher appears on site, little organizational work has been done."[9] But of course that's not entirely true. As many of the photographs in this book attest, places resonant with historical meaning have often been imbued with significance by the people and social forces that have "organized" their public, commemorative face, although not always with the official stamp of state authorities. Indeed, it would be a mistake to conclude that "unmarked" sites of memory have simply been forgotten. In the absence of official recognition, these sites remain a singular part of a local "social memory" for particular communities, sometimes surreptitiously so. If the spot at which a black person was lynched has been "forgotten" by local whites— indeed, if the public memory of the event, as dictated by whites, has been expunged—you can be sure that the local black community damn well remembers. When racist graffiti appears in the same spot a century after the event, is this a sign of deep social amnesia or, more sinisterly, covert memory? In the absence of written history or public acknowledgment—or in the presence of written accounts that deny the voices of the victims—oral tradition often leaks in to preserve painful, even dangerous, memories. For example, in returning to Apache oral accounts of the Camp Grant massacre, anthropologist Chip Colwell-Chanthaphonh was able to supplement the tendentious written record that presents only the views of white settlers and the U.S. military. In doing so, he also "provides an alternative way to contemplate how the

past is recalled"—one that is, among other things, much more rooted in a close knowledge of the physical landscape that was the site of the events woven into oral tradition. Indeed, like many oral accounts of past events by nonliterate peoples, the Apache tales of the Camp Grant massacre use place names and geography as narrative markers, rather than the specific chronology that traditionally anchors written accounts of the past. I like to think that Andrew's photographs, with their frequent attention to landmarks not always emphasized by "official" memorialization, offer a visual correlative to this method of recounting—and reclaiming—the past. That said, as Ari Kelman documents in his account of disputes over how to memorialize the Sand Creek massacre in Colorado, victims and perpetrators sometimes cannot even agree on *where* precisely an event occurred, let alone what happened and how responsibility might be apportioned and justice rendered.[10]

The first section of this book, "Marked," does consist of photographs of sites that have received the endorsement of commemoration by local, state, or national authorities. While not always true to the nature of the commemorated event itself, these sites repeatedly ask visitors to contemplate the past and to consider events as an integral part of "heritage." There were many places for Andrew to choose from; it is certainly not as if Americans fail to commemorate historic sites, even—perhaps especially—those associated with violence and national trauma. But as Marita Sturken points out in her book *Tourists of History*, such commemoration, "repackaged as tourist practices and cultural reenactment," risks posing history as an object of consumption. By reducing history to kitsch, Sturken claims, such commemorative activities can offer "a renewed investment in the notion of American innocence." What Sturken calls the "tourism of history" then does allow us to visit the past, but only on a journey that replicates the most inauthentic of tourist destinations.[11]

Sturken reminds us that "tourism is about travel that imagines itself as innocent; a tourist is someone who stands outside of a culture, looking at it from a position that demands no responsibility." In the cases of the sites of brutal subjugation, dispossession, and anti-labor violence that appear in this book, responsibility for a shared past is in constant danger of displacement by the ineradicable fiction of "American exceptionalism," the myth that American purity of intention has made the nation's past perfectly just, and thus unlike any other nation in history. Andrew's photographs of marked sites, however, provide a potential antidote to this indulgence in reducing historical memory to what Sturken calls "comfort culture" and American history to an unblemished march to democracy and a "more perfect union." His camera captures the margins of these commemorative sites, suggesting how the landscape might have looked at the time of the event itself, rather than after being smoothed over by the commemorative process. In doing so, he upends the touristic practice of photographic authentication of the commemorative experience, the fetishistic act of "taking" a picture at and from memorial sites as a validation of a purely subjective experience of mourning or remembrance. Instead, Andrew's photographs ask viewers to stop and look, to place themselves back inside of a culture, and perhaps indeed to embrace responsibility for the past. As Andrew told an interviewer,

> Photography, in this case is paralleling the study of history itself. History is never about the past. It's always about how we are viewing the past in the present. What we select to be interested in, what we are interested in, what we choose and how we view it. It's all about where we are at now.[12]

Indeed, photography can be an especially powerful tool for reconfiguring these sites, for traditionally the camera has been complicit in fixing iconic imagery to historic events. As

described in the book *No Caption Needed*, "with the iconic image [provided by a photograph], social knowledge is fused with a paradigmatic scene." At the same time, photography's implicit—it deeply deceptive—claim to recording verisimilitude, to replicating the exact feeling of "being there" at a moment an event occurred, has both given this media democratic possibilities and yet allowed it all too easily to fall prey to the commodification of the past, as

Site of the 1863 New York City draft riots, 2015

Sturken suggests.[13] Andrew's photographs of "marked" historic sites, I think, conjoin these two approaches, serving as what I would call "anti-iconic" representations that contain within them the capacity to rethink our place in history and to rechannel remembrance.

Andrew has always insisted, however, that "some of the most interesting places . . . are where there is no recognition of the past whatsoever. But these are the hardest pictures to make. You want some connection to the historical event that happened there but the fact that

there is none, I find fascinating."[14] Part two of the book, "Unmarked," presents photographs of sites that have been neglected, forgotten, or in some cases, deliberately obscured. As Foote puts it, "the invisibility of so many events of tragedy and violence seems to indicate a tolerance or acceptance of such events as fundamental elements of American life," deserving of no apology, no surrender, no retreat, no reconciliatory gesture, and no place in our heritage or public memory. (Although such silence could also be a sign of shame.)[15] Here the photographs serve as a mnemonic tool with the hope of re-inscribing a denied violent past on the landscape and built environment. That said, one does have to ask what happens if and when such sites receive long-deferred public acknowledgment. Marking a site, while freeing it from the oblivion of repressed memories, also can encapsulate its meaning within a fixed narrative, one often consecrated by—and captive to—national, ethnic, or community interpretive interests of the moment.[16]

The final section of the book, "Remembered," consists of photographs of individual and collective local efforts to commemorate crucial events in the face of official disinterest or denial. Sometimes this might appear as a solitary moment of quiet contemplation; sometimes a ceremonial recreation. In many instances, these acts of remembrance fuse chronological time with physical space; that is to say, they occur at a significant physical location *and* at a designated commemorative moment, marking both: April 4, March 7, March 25, December 26. These moments of pilgrimage can and should be contrasted to commemorations sponsored by the purveyors of officially sanctioned—and thus packaged—memory. According to historian of memory John Bodnar, custodians of "official" culture "orchestrate commemorative events to calm [popular] anxiety about change or political events, eliminate citizen indifference toward official concerns, promote exemplary patterns of citizen behavior, and stress citizen duties over rights." And let's not forget the object of recruiting tourist dollars to otherwise hard-

pressed communities. Some of Andrew's photographs —"Rodeo Days of '76, in Deadwood, South Dakota," for example—document this kind of event, to be sure. But his photographer's eye is more often caught by what historians of public memory call "vernacular" forms of commemoration. In contrast to government or chamber of commerce–approved forms of heritage, these images represent an unselfconscious grassroots desire to connect a painful

Remembering the 1968 Orangeburg Massacre, South Carolina, 2012

past to the present. For example, residents of Galveston, Texas, gather to commemorate slave emancipation, known in Texas as "Juneteenth," or members of the Dakota Sioux tribe ride to Mankato to recall the fate of their ancestors sent to the gallows by Abraham Lincoln in 1862. As Bodnar puts it, cultural, political, and economic elites "use the past to foster patriotism and civic duty, and ordinary people continue to accept, reformulate, and ignore such messages." Indeed, vernacular commemoration "threatens the sacred and timeless nature of official

expressions" of public memory.[17] Some of Andrew's photographs here certainly remind us of the power of the vernacular to contest hegemonic representations of the past; for, as Glassberg remarks, "as the marketplace through which we interact with the world becomes more impersonal, we want our histories to become more intimate," inflected with particularistic concerns.[18] If Andrew's images of marked sites can be regarded as anti-iconic, I would say those in the section we have entitled "Remembered" engage in the de-commodification of historical reenactment.

Although we have organized the book around sites that we regard as marked, unmarked, and remembered, on occasion these categories necessarily overlap and bleed into one another. Some commemorated sites have unmarked fringes, often more interesting than the monument itself; some places have previously been marked, and subsequently unmarked (the John Mason statue in Mystic, Connecticut, is a good example); and in some cases, a site designed to commemorate one past has been deployed by people who use it to remember another, either deliberately or out of ignorance.[19] Moreover, marked sites, like the gravesite to the Haymarket anarchists executed by the State of Illinois in 1888, become remembered sites during annual pilgrimages—in this case, on May Day, a holiday founded to consecrate their legacy and martyrdom. No doubt by the time readers encounter this book, some of the unmarked sites included here will have received more formal acknowledgment, although what form that commemoration will take is always hard to guess. Vernacular remembrance can easily be reappropriated by local commercial and political elites, who recognize a good marketing prospect for their community when they see one. As Kate Brown points out, "at some point even the wreckage progress leaves in its wake becomes profitable."[20] All of these sites, however, provide the opportunity to reflect on the way the past appears on both natural and human-made

landscapes as if on a palimpsest, and how the photographic image can display aspects of that past, scratching at the surface of the present to disclose the hidden history underneath.

Rather than simply fixing history in place, "commemoration creates new narratives about history that allow people to interact with the past in a way that they find meaningful." What people and communities "find meaningful," however, is hardly a natural or uncontested process.

Haymarket Martyrs Monument, Forest Park Cemetery, Illinois, 2009

Instead, ascertaining meaning in a conflict-ridden violent past—and giving it corporeal form as a monument, statue, state marker, historical designation, or museum— is always fraught with power, beset by contending pressures from the state, civic groups, commercial interests, and individuals with a stake in local historical interpretations and in the consecration of memory. As I hope I have suggested in this essay, over the past few decades American historians have

paid a great deal of attention to these memory struggles as they have reconsidered the rich, intertwined histories of Americans whose voices have too often been silenced. The landscape whispers of these pasts too; we are fortunate that Andrew's photographs help us to listen. As Andrew says,

> the photographs I've taken, and continue to search for, are as much about what is here now, in the 21st Century, as they are about an elusive past. I'm interested in a history of violence and conquest, and the struggle for freedom and equality, because I see these themes as very much still with us today.[21]

MARKED

Site of King Philip's Death, Miery Swamp, Bristol, Rhode Island, 2010

A small stone monument erected in 1877 marks the spot in the Miery swamp outside of Bristol, Rhode Island, where Metacomet, known by his English antagonists as King Philip, was finally tracked down and killed in 1676. The Wampanoag warrior, who had led a rebellion that managed to burn down much of colonial New England in the 1670s, had one of his hands chopped off and given to the Christian Indian scout who fired the fatal shot. English colonists displayed Philip's head on a stake at the entrance of nearby Plymouth for twenty years, and sold his wife and son into slavery in the West Indies. The proceeds from the sale of hostile Indians as slaves were customarily divided among the leaders of the colonial militias.

Bread and Roses Strike, Everett Mills, Lawrence, Massachusetts, 2011

By 1900, the town of Lawrence, Massachusetts, stood at the center of New England's textile industry. Gigantic factories along the Merrimack River employed tens of thousands of young immigrant women, who worked under harsh conditions for very low wages. Organized by the radical Industrial Workers of the World, in the winter of 1912 the women walked out of the mills in response to a pay cut, touching off what became known as the "Bread and Roses strike," so named after a banner carried by strikers proclaiming "We Want Bread, and Roses Too." In 2011, the Everett Mills, where the walkout began, and where National Guard troops bunked during the strike, was a half-remodeled building. Today, advertising "an interesting mix of first class office, high tech, health and human service providers, manufacturing, and distribution businesses," it anchors the latest urban renewal plan designed to save the economically depressed town.

Emmett Till Murder, Cotton Field, Money, Mississippi, 2010

During the summer of 1955, a fourteen-year-old black boy from Chicago named Emmett Till was visiting relatives in the small Mississippi Delta town of Money. While buying candy at Bryant's Grocery, he either whistled at the white woman who ran the store, said "bye baby," or in some other trivial way violated the strict racial and sexual barriers that defined the segregated South. Whatever petty infraction young Till had committed, he quickly became part of something much larger than himself. Kidnapped, beaten, and murdered, Till's mutilated body was dumped by his killers into the nearby Tallahatchie River, weighted down with a cotton gin fan. His mother insisted on an open-casket funeral to expose to the world the brutality of segregation. Till's murderers were quickly set free by an all-white jury, even as they openly admitted to the crime. Anger over the injustice of this murder helped spark a new phase of the civil rights movement.

Although there is a small historical marker outside Bryant's derelict storefront, mostly what remains in Money today are fields of cotton, the cash crop so intimately tied to slavery, sharecropping, and racial domination. To travel in the Delta today is to visit one ghost town after another. The large industrial farm machines that replaced the field hands accomplished what the white supremacists could not, driving the region's blacks up the Mississippi, toward jobs and potential freedom in the North.

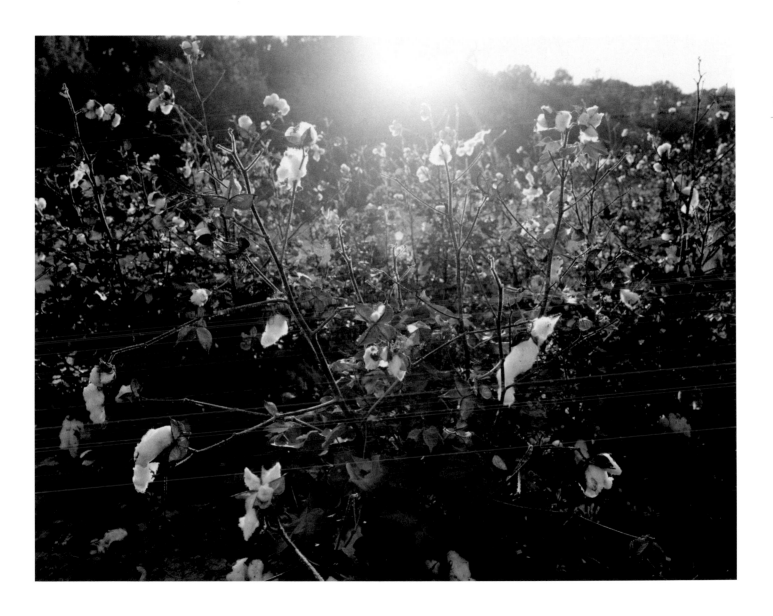

Maroon Fort, Franklin County, Florida, 2014

Early nineteenth-century Florida was a contested place, with few guarantees that the young American republic would control the region. The British, Spanish, Americans, Seminoles, Creeks, and escaped slaves (known as the maroons) all competed for power and survival in the swampy wilderness. During the War of 1812 the British built a fort along a bluff overlooking the Apalachic-ola River, and left it and the cannons defended by a force of hundreds of escaped slaves under the military command of a black man known only as Garson. Referred to as the "Negro Fort," the installation posed a military threat to the United States. It also stood as a rare example of an organized maroon colony in North America and thus represented a challenge to the institution of slavery itself, serving as a magnet for Southern slaves fleeing to freedom. In 1816, the U.S. Army attacked the fort; a shot from a naval gunboat on the Apalachicola hit the powder magazine, creating an enormous explosion that killed many of the African American inhabitants. Victorious U.S. forces sold the survivors back into slavery.

The fact that we know so little about Garson or this exceptional community fighting for free-dom on the American frontier is not surprising. This was not a battle America's slave owners or their descendants wanted to publicize. Today, the U.S. Forest Service has preserved the site, called Fort Gadsden, in the heart of the remote and wild Apalachicola National Forest. The fortifications can still be clearly seen rising out of the land, overlooking the river, but much has been lost to history.

Site of the Ludlow Massacre, Ludlow, Colorado, 2009

On April 20, 1914, Colorado National Guardsmen, John Rockefeller's Colorado Fuel and Iron guards, and private detectives attacked striking coal miners and their families in the tent city they had established after being evicted from their company-owned homes. The strikebreakers mounted guns on railroad cars, and fired indiscriminately into the tents, killing up to two dozen people and setting fire to the encampment. Four women and eleven children were burned to death as they huddled in their tent. In response, enraged miners armed themselves and sought vengeance against the militia and armed company guards. For his part, Rockefeller hired a public relations consultant to repair his damaged image. A monument to the victims of the massacre, erected by the United Mine Workers Union and the National Parks Service in 2009, stands just to the east of the railroad tracks.

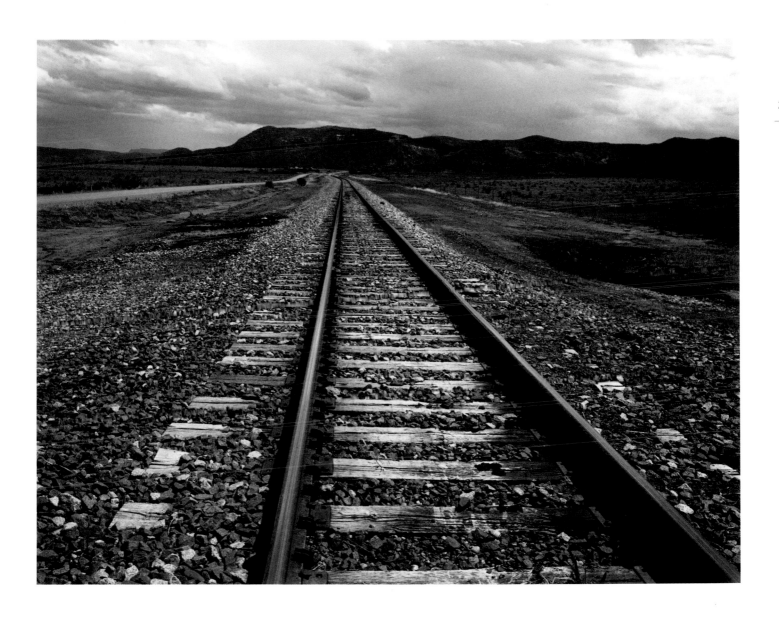

Bosque Redondo Memorial, Fort Sumner, New Mexico, 2016

In an effort to subdue the indigenous peoples of the New Mexico Territory during the 1860s, Gen. James H. Carleton and Col. Kit Carson forced the Mescalero Apache and the Navajo peoples to Fort Sumner, and interned them on the adjoining Redondo Bosque reservation along the banks of the Pecos River. Three hundred Navajo perished on their forced "Long Walk" to Fort Sumner. By 1864, five hundred Apaches and 8,500 Navajo were consigned by the U.S. Army to the reservation, with the intention that these nomadic people would be compelled to subsist as sedentary farmers. General Carleton envisioned Bosque Redondo as a model agricultural community, designed to "civilize" the Indians in his charge, but the alkaline water of the Pecos proved unfit for drinking. Navajo lore came to refer to Bosque Redondo as *hweeldi*, or "the place of suffering."

The Bosque Redondo Memorial, established and maintained by the State of New Mexico, notes the irony that at the moment President Lincoln issued the Emancipation Proclamation, "he was setting the stage for another period of slavery of the Mescalero Apache and Navajo people."

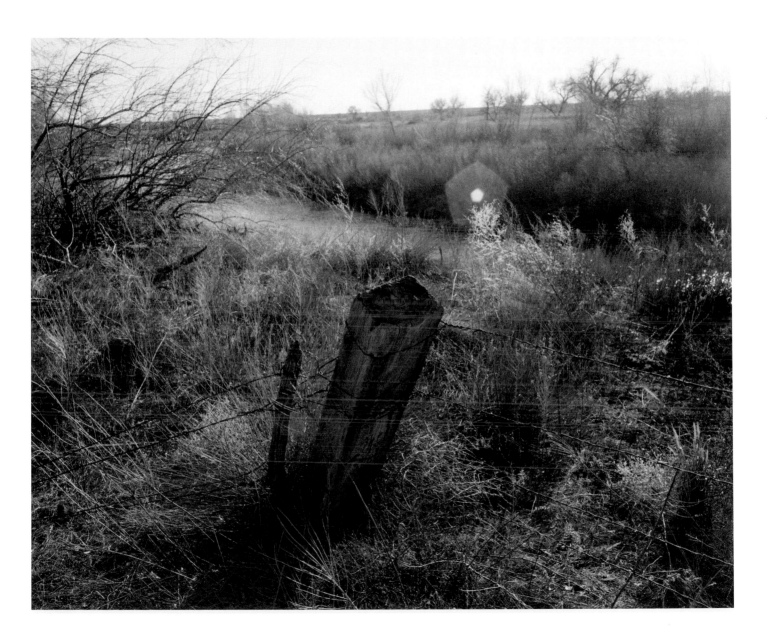

No Rent Rebellion, Moses Earle's Farm, Andes, New York, 2009

In the 1830s and 1840s, the rural counties of New York state's Hudson Valley were ruled by a small group of wealthy Dutch-descended families. These absentee landlords controlled over two million acres of land and dictated the lives of thirty thousand tenant farmers. The unforgiving conditions of this feudalistic system led to the No Rent Rebellion. Tenant farmers formed secret Anti-Rent associations, disguised themselves as Indians, and refused to pay rent or have their farms sold off. During the summer of 1845, a Delaware county undersheriff was killed by a large group defending Moses Earle's livestock from being auctioned on his farm outside of Andes, New York. The governor declared Delaware and the surrounding counties to be in a "state of insurrection," and many Anti-Renters were arrested and sentenced to die by hanging. In 1846, they received a pardon from a more sympathetic new governor elected with political support from upstate farmers. All that remains of Earle's farm today is this crumbling foundation on the edge of a field in rural Delaware County.

Jackson County Courthouse, Scottsboro, Alabama, 2011

Portraits of the county's past sheriffs cover the walls of the sheriff's office in the Jackson County courthouse in Scottsboro, Alabama. To look at photographs of elected officials in America offers a glimpse into a repressive past. Although blacks made up over 80 percent of the population in many Southern counties, from the end of Reconstruction in 1876 until the Voting Rights Act of 1965, blacks were systematically denied their constitutional right to vote. It was in this courthouse that the Scottsboro "boys," nine black teenagers falsely accused of raping two white women in 1931, were first brought to trial. Their trial and subsequent appeals became the most important racial case of its era, and led to some significant due process rulings in the higher courts. Despite the death sentences the defendants initially received, and the many years they spent in prison while their lawyers appealed to the Supreme Court, they were the lucky ones. Most African Americans accused of raping a white woman in the Jim Crow South never made it to court, losing their lives instead "at the hands of parties unknown."

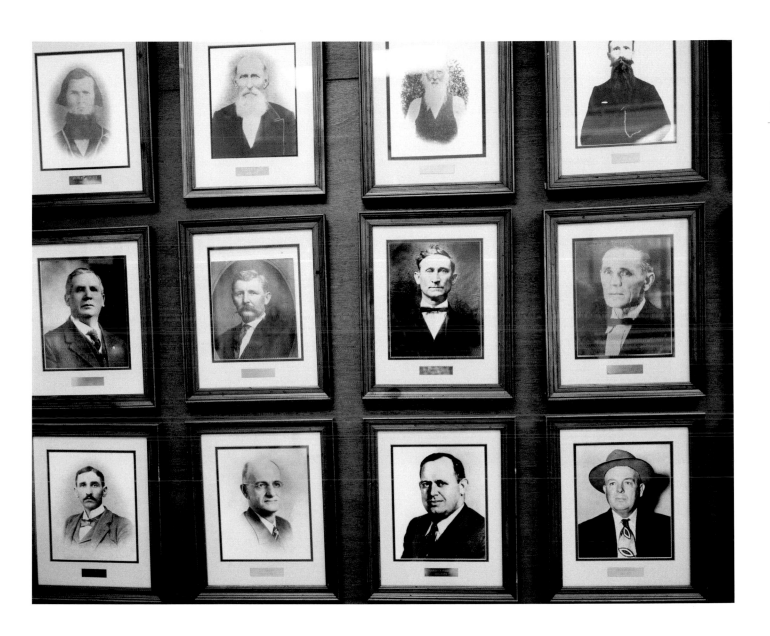

Martin Luther King Jr. Day Parade, Greenwood, Tulsa, Oklahoma, 2016

By 1921, the Greenwood section of Tulsa had become one of America's wealthiest black neighbor-hoods, with a firmly entrenched middle class and a shopping district stretching along Greenwood Avenue, just north of downtown. Developers with links to the Ku Klux Klan coveted this desirable land, however. When black World War One veterans in the neighborhood defended a local young African American man from being lynched, the stage was set for America's most destructive race riot. For two days armed white mobs attacked Greenwood, even using airplanes to firebomb and shoot black residents. The mob burned thirty-five blocks of Tulsa to the ground, leaving ten thousand people homeless. Police detained six thousand residents, and rampaging whites mur-dered anywhere from fifty to three hundred blacks. Although Tulsa's African American community rebuilt their neighborhood after the riot, urban development of the 1960s and 1970s ultimately destroyed the area more successfully than any white mob. For decades, little mention was made of this racial pogrom in the city's schools or public sphere. In 2010 the State of Oklahoma and City of Tulsa finally established a well-maintained memorial park dedicated to the events of May 31, 1921, but Interstate 244 overhead has left this once thriving, vibrant neighborhood with little economic development.

Pullman Homes, Chicago, Illinois, 2012

Built in the 1880s by George Pullman, the owner of the Pullman Palace Car Company, Chicago's Pullman neighborhood was one of the first company towns constructed in America. Workers paid rent to the company and lived in row houses assigned according to their jobs. The Pullman corporation sought to regulate every aspect of its workers' lives. When they went on strike in 1894, the neighborhood became the epicenter of a national sympathy strike led by Eugene Debs and the American Railway Union. Faced with a national rail boycott, the U.S. government called in federal troops to break the strike. Tied to the economic well-being of the railroad industry, and declared a National Landmark Historic District, the neighborhood has gone through several booms and busts before becoming part of Chicago's struggling and now largely black South Side.

Fisher Body Plant 2, Flint, Michigan, 2016

General Motors' gigantic manufacturing center in Flint, Michigan, was named "Chevy-in-the-Hole" for the cars made there, and for the physical depression of the land itself as it hugged the banks of the Flint River. The plant's workers played a key role in the Flint sit-down strike during the winter of 1936–37. Their victory over local police who stormed the gates of the Fisher Body Plant helped establish the United Automobile Workers (UAW) and led to the formation of America's modern industrial unions under the AFL-CIO. Organized labor ushered in half a century of economic progress for the city of Flint, for the union laborers working the line, and for General Motors. Today, the eighty thousand manufacturing jobs that underlay Flint's economy are gone, and the once powerful and historical union halls have only retirees as members. The great factories have been torn down and paved over, leaving a concrete scar on the shrinking, impoverished, and ecologically devastated city.

Henry Ford Statue, Gate 4, Ford River Rouge Plant, Dearborn, Michigan, 2016

At its peak in the 1930s and 1940s, Henry Ford's River Rouge vertically integrated and self-sufficient automobile assembly plant outside of Detroit produced four thousand cars on its assembly line every day. The largest factory complex in the world at the time, "the Rouge" employed over 100,000 workers. Ford was notorious, however, for his bitter resistance to the efforts of the United Automobile Workers to organize his plants, and he hired a crew of thugs in his "Service Department" to intimidate union organizers. For the union, however, the Rouge was the prize. In May 1937, in the wake of the successful sit-down strike at General Motors, "Service Department" goons assaulted UAW organizers Walter Reuther and Richard Frankensteen on the pedestrian overpass connecting the complex to the street near Gate 4. Not until 1941 did Ford become the last auto manufacturer to sign a contract with the UAW. This statue of Henry Ford guards the gates of the Rouge today, as well as the overpass itself.

Site of the Sand Creek Massacre, Eads, Colorado, 2009

On the morning of November 29, 1864, Col. John Chivington led a group of soldiers from the 3rd Colorado Regiment in an attack on a Cheyenne and Arapaho village of women, children, and old men. After attempting to make peace, Cheyenne chief Black Kettle had been ordered by the U.S. Army to camp along the banks of Sand Creek and fly an American flag. However, this did not protect the Indians from Chivington's attack, which killed at least 150 people. Quickly realizing that this was an assault on a peaceful village, two officers held back their men and refused to participate. A congressional inquiry in 1865 concluded that Chivington had "deliberately planned and executed a foul and dastardly massacre." Despite the fact that federal officials defined the violence at Sand Creek as a massacre, there ensued a century-long effort, drawing on John Chivington's recollections, to whitewash the event. In 2007 the National Park Service purchased the ranch land where the massacre took place, and it became a protected National Historic Site. You know you are near the site when you pass the railroad crossing still named Chivington.